Theory & Methods

Scraps strings. Love them, overwhelmed by them, want to use them, but wondering where to start? Right here in the Stash Lab! This is a great place to experiment, try new ideas, and most importantly, have fun! All of the projects in String Theory feature cut strips of fabric 1½"-wide of various lengths. Call them "strings", call them "skinny strips", I just call them wonderful!

String quilts have been around for a long time and were basically a thrifty method of using up scraps. Often they were foundation pieced on a backing fabric or newspaper using narrow strips of cloth cut from a variety of fabrics. These could be from worn out or mended clothing, household linens, or just about anything, even cigar ribbons! More recently, string quilts featuring fabric selvages were popular as well. Foundation piecing methods are not always necessary when using uniform strips cut on the straight of grain. Only one of our projects, Simple Gifts, utilizes a muslin foundation piecing method.

COLOR-BLOCKING TECHNIQUE WITH SCRAPS

A technique I like to use when working with scraps is Color-blocking. Color-blocking is a term often used in fashion and design and usually refers to a garment or outfit that is composed of limited blocks of solid color and plays with opposites on the color wheel.

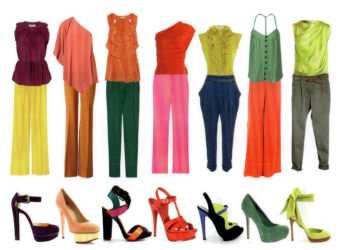

Examples of color-blocking in fashion

MY BOOK
For more project ideas for your stash, check out Stash Lab: Simple Solutions for Scrap Quilts. It features three scrap equations for successful scrap quilts and eleven projects that combine scraps of fabric into striking quilts that put a modern spin on traditional quilt blocks.

Follow
STASH LAB QUILTS
Instagram: @stashlabquilts

Facebook.com/ Stash Lab Quilts

Learn more at
STASHLAB QUILTS.COM

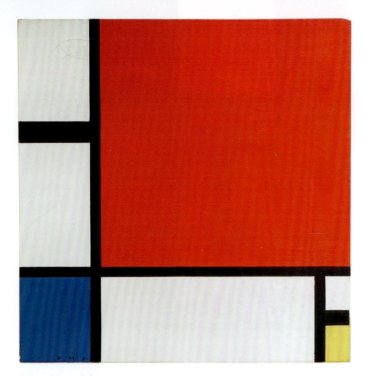

The color-blocking trend in fashion is often credited to Dutch painter Piet Mondrian of the early 20th century.

The first rule of color-blocking in fashion is to avoid prints – and that's the biggest difference with what we're going to do with our scraps in the Stash Lab! Printed patterns call attention to themselves, whereas the goal of color-blocking is to let the whole outfit work together so they stick with solid colors.

We're going to do something of the opposite but to achieve the same affect. We're going to combine as many prints as possible in the same color family to create a new fabric that will "read" as our solid color in our design. When it comes to scraps, the overall effect is often greater than the sum of the parts.

**Piet Mondrian,
Composition II in Red,
Blue, and Yellow, 1930**

Let's look at some examples...

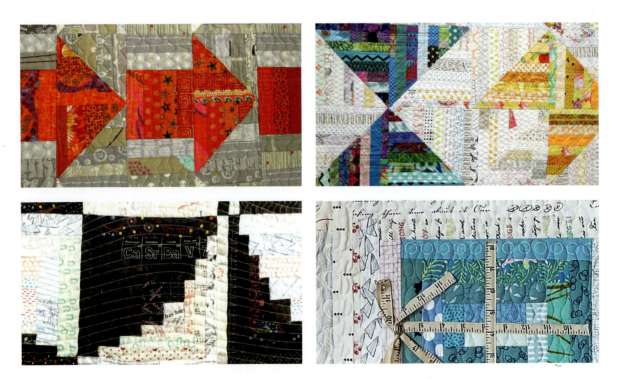

The projects in our lab manual focus and utilize fabric strips but the same concept can apply to any shape you are working with.

Here's an example of applying the color-blocking of scraps but using 60° triangles instead of strips. The secondary design of the diamonds is created solely by color-blocking the fabrics.

LET'S TALK LOW VOLUME

"Low volume" refers to a wide variety of printed fabrics on light backgrounds. The backgrounds can be white, cream, beige, gray or even pastels. While lovely on their own, low volume fabrics do the important job of creating contrast with your darker, brighter fabrics.

Drawn by color, we often gravitate to the medium to darker tones of fabrics and leave the low volume fabrics for the backgrounds.

Low volume fabrics can be mixed together to create subtle interest and provide contrast to your other fabrics that will help you create your overall design.

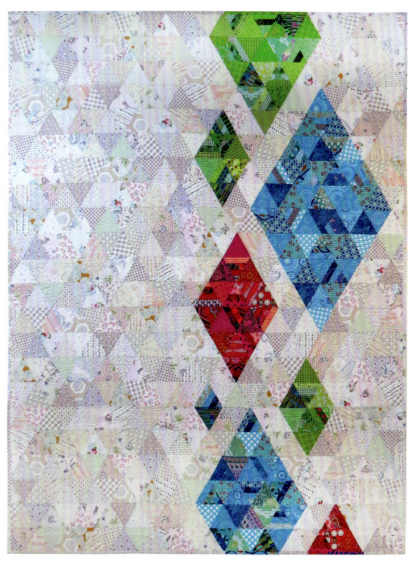

Diamonds in the Rough by Tonya Alexander

Just like color blocking with darker colors, don't be afraid to mix, mix, mix. Interest is created with fabrics because of their differences, not because they're all the same and blend together. This is even more important when it comes to low volume fabrics because the interesting prints you bring to the mix are what make it better. You're first inclination may be to stick to solids or tone-on-tone whites but be brave, be bold!

Another hint is to always consider the back of your fabric. If a print seems a little too bold or bright, turn it over before ruling it out. The back may be just the shade you are looking for. Also, keep in mind that once you place your low volume areas next to brighter, darker colors , the darker colors will become the primary visual focus. A print that initially seems to stick out too much in your low volume areas, may be fine after they have some more competition drawing the eye away to the brighter colors.

SORTING AND STORING

One thing is certain: the longer you quilt, the more scraps you are going to generate! I like to save my scraps in ready-to-go sizes so that they are easier to work with and more likely to be used than a big bin full of mixed sizes and bits and pieces. My favorite small size strip is 1½" –wide strips. No matter how I use them, with a ¼" seam allowance, they always finish in 1" units which makes the quilt math easy and I'm more readily able to incorporate them into any project.

A note about bins. Any fun shape, color, or design that works in your sewing space is an option. I like clear or opaque bins that are stackable with lids and I add labels to the ends. I also like to use chalkboard labels found at my local craft store so that I can change the label quickly and easily.

Depending on your amount of scrap strings, you can consider the best way to store them. You can:

· keep them all in one bin

· divide into two bins, color/dark strings in one and low volume strings in another

· divide into three bins: warm colors (oranges, reds, pinks, etc.), cool colors (blues, greens, purples, etc.), and low volume

· divide even further into individual bins for each color!

By sorting and storing your scrap strings in this way, it's helpful when deciding which project to do or what should come next. If one particular bin is over-flowing, there's your potential next project. Also, if a particular bin is a bit low for the project you want to begin, it helps organize you as you go to your stash shelves to cut off individual strips from certain color groups that need a boost.

GENERAL NOTES ON CONSTRUCTION FOR ALL PROJECTS

A few tips for all of the projects:

Cutting: When cutting 1½"-wide strips, make sure you are cutting on the straight of grain on the fabric and not on a biased angle. This is easiest to do if you are cutting from a full width of fabric or if you have at least one selvedge edge to align your ruler. If you don't have the benefit of that edge on the scrap you are cutting down, align your ruler along the weave of the threads. Cutting on the straight of grain will reduce fraying of the edges of your strips and will help keep your strip sets from warping when you sew them together.

Seam allowance: For projects where you are joining a lot of small pieces, using a consistent ¼" seam allowance throughout your piecing is strongly encouraged. Even if this normally isn't high on your list, these projects are going to have a lot of seams and if your seam allowance is off, you are going to multiply that seam difference across the entirety of the quilt top. What seems like not a big difference in a single block, can become one very quickly across the quilt top and can cause frustration when your block seams don't meet nicely.

Making the strip sets: Keep your strips at 22" maximum length in your strip sets. (This is the long length of the average quilter's favorite fat quarter.) Alternate the direction you are feeding the strip sets through your machine as you are adding additional strips. (For example, adding a strip onto the right, and then turning the strip set and feeding in opposite end first when you add a strip on the next pass through.) The alternate tension of the stitches and limited length of the strips will help reduce the chance of bowing or curving of the strip set.

Pressing: In general, press seam allowances in each strip set all in one direction.

Take a trip around the world: When you're done piecing your quilt top, run a securing stitch line all the way around the edge of the quilt top about ⅛"-¼" from the edge. This will lock down all of the seams — you will have a lot! This will help prevent seams from pulling apart and distorting your quilt top either before or during quilting. If you keep this line of securing stitches ¼" from the edge or less, it will automatically be covered by the binding when you attach it and there's no need to remove it. It will be invisibly tucked inside your binding.

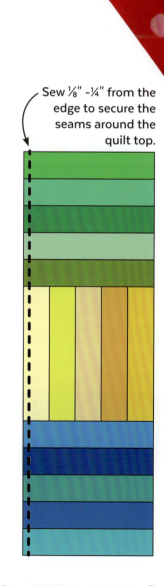

Sew ⅛" -¼" from the edge to secure the seams around the quilt top.

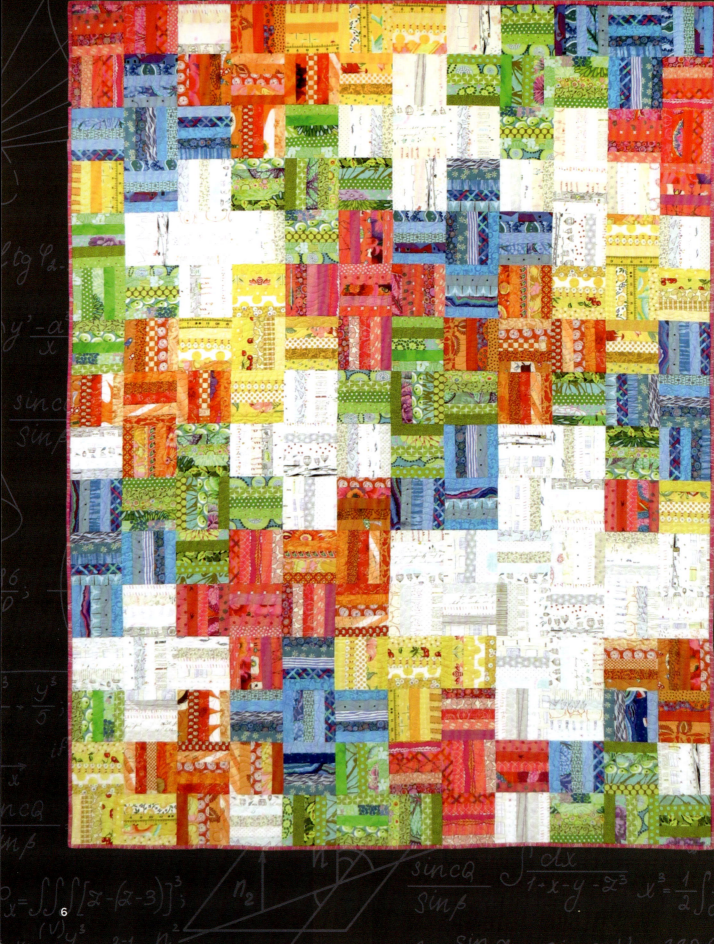

Calliope

Calliope is a modern, scrappy take on a traditional plus quilt design — utilizing the color-blocking technique with scrap strips to create strip sets for the blocks instead of traditional single fabric selection for each "plus". The layout and inclusion of an over-sized low-volume "plus" are examples of alternative gridwork common to modern quilting. A design wall is a definite help with this design to keep blocks in order to create the secondary design of the plus signs.

MATERIALS

- Scrap strings 1½" x 22" in a variety of fabrics, grouped into pinks, blues, greens, oranges, yellows, and low volume/lights. Assorted mix from your stash or easy to cut from fat quarters*.

 Fabrics in Calliope include a wide variety of scraps. When selecting fabrics for each color group, consider a variety of prints and patterns. When the different fabrics are put together in their individual color groups, they will "read" as a solid color to make the plus signs in the quilt design. To make as shown, you'll need enough assorted fabric strips total of:

 — 4 fat quarters each yellow, orange, and pink fabrics

 — 5 fat quarters each blue and green fabrics

 — 8 fat quarters each low volume/light fabrics

- 5 yards backing fabric
- 70" x 90" batting
- ⅔ yard for binding

* Fat quarter = 18" x 22"

LAB NOTES

Finished quilt: 60½" x 80½"

Finished block size: 5" square

My notes:

CUTTING

Measurements include ¼" seam allowances.

From fat quarters of each of the colors, cut:

- Yellow: 40 strips, 1½" x 22" to make 8 yellow strip sets.
- Orange: 45 strips, 1½" x 22" to make 9 orange strip sets.
- Blue: 55 strips, 1½" x 22" to make 11 blue strip sets.
- Green: 60 strips, 1½" x 22" to make 12 green strip sets.
- Pink: 40 strips, 1½" x 22" to make 8 pink strip sets.
- Low volume/light: 90 strips, 1½" x 22" to make 18 low volume/light strip sets.

From the binding fabric, cut:

- 8 - 2½" x width of fabric strips.

MAKE THE BLOCKS

1. Select 5 strips 1½" x 22" of the same color group. Sew along the long sides to create a strip set measuring 5½" x 22". Press seam allowances in the strip set all the same direction.

5½" x 22"

2. Cut the 5½" x 22" strip set into 3 squares 5½" x 5½".

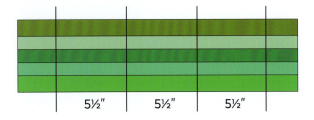

5½" 5½" 5½"

3. Repeat steps 1-2 to make the following strip sets and blocks:

- Yellow: 8 strip sets, cut into 23 yellow blocks
- Orange: 9 strip sets, cut into 27 orange blocks
- Blue: 11 strip sets, cut into 32 blue blocks
- Green: 12 strip sets, cut into 35 green blocks
- Pink: 8 strip sets, cut into 23 pink blocks
- Low volume/light: 18 strip sets, cut into 52 low volume/light blocks

 For a total of 192 blocks.

ASSEMBLE THE QUILT TOP

4. Arrange the blocks as shown in the Quilt Assembly Diagram. Notice the alternating horizontal and vertical direction of the blocks.

5. Sew the blocks together for each row. When joining the blocks in each row, press toward the horizontal single fabric strip.

6. Sew the rows together and press the seam allowances all in the same direction.

7. Take a trip around the world! Sew a securing stitch line all the way around the edge of the quilt top between ⅛"-½" from the edge to secure all of the seams.

FINISH THE QUILT

Layer the quilt top, batting and backing. Baste, quilt, and bind as desired.

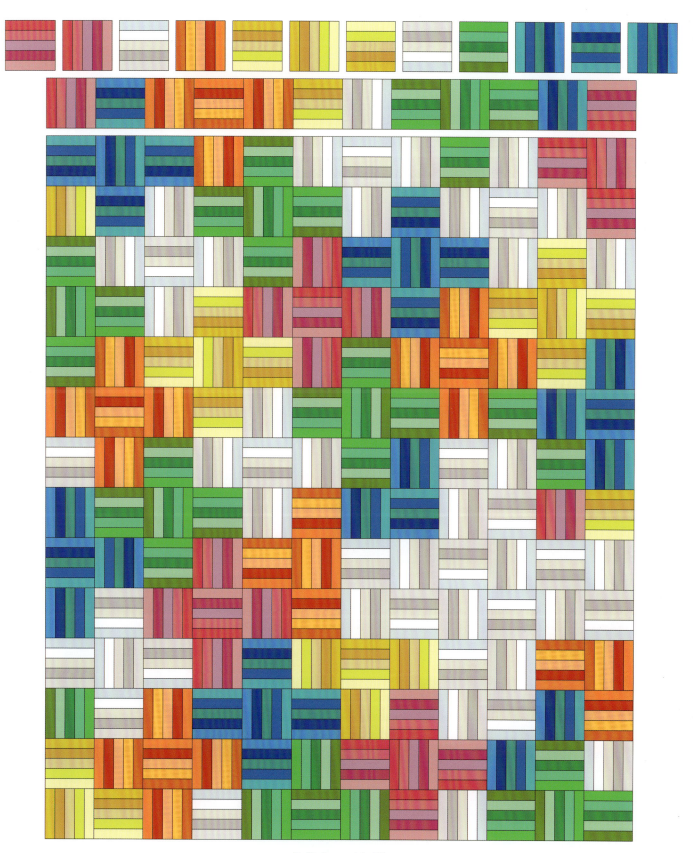

Quilt Assembly Diagram

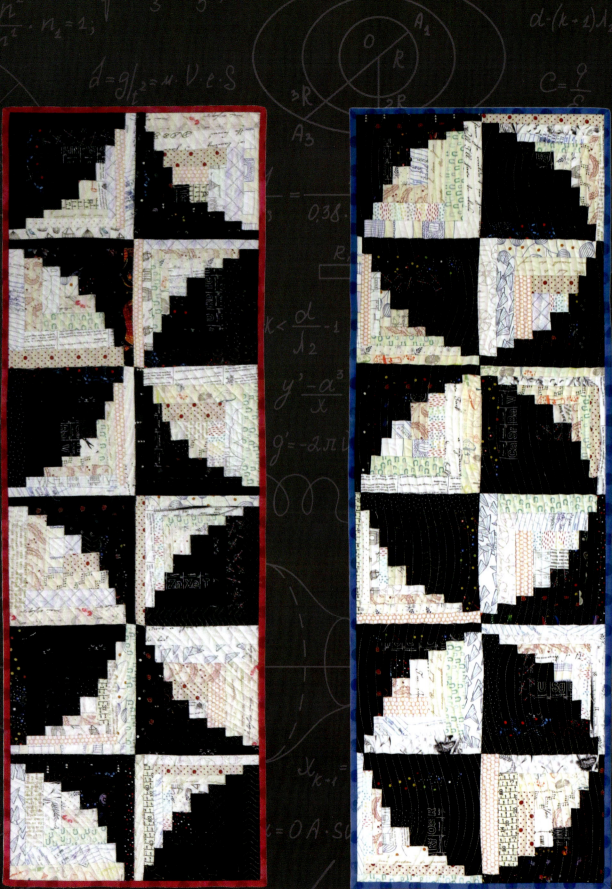

Domino

a table runner two ways

The quintessential example of a string quilt block is the traditional log cabin quilt block. The Domino table runner features a curved rendition of the classic block by using 1½″ -wide strips for the convex side of the block and a slightly smaller 1″ -wide cut strip for the concave side of the block. There's no curved piecing, just the fun and easy optical illusion of curves.

For either layout option as shown, you'll need to make 6 A Blocks and 6 B Blocks. Stick with the graphic black prints and low volume prints for the classic domino, or contrast the low volume prints with your own favorite mix of another dark color. Either way, 12 blocks never looked so bold and beautiful!

MATERIALS

- ¾ yard total assorted light/low volume print scrap fabrics
- ¾ yard total assorted dark/black print scrap fabrics
- ¼ yard bright print fabric for binding
- 1 yard backing fabric
- 18″ x 50″ batting

CUTTING & MAKING THE A BLOCKS

Measurements include ¼″ seam allowances.

For the A blocks, from your dark fabrics, cut:
- 6 – 1½″ x 1½″ squares (A on the block diagram)
- 6 – 1½″ x 2½″ strips (#2 on the block diagram)
- 6 – 1½″ x 3″ strips (#5 on the block diagram)
- 6 – 1½″ x 4″ strips (#6 on the block diagram)
- 6 – 1½″ x 4½″ strips (#9 on the block diagram)
- 6 – 1½″ x 5½″ strips (#10 on the block diagram)
- 6 – 1½″ x 6″ strips (#13 on the block diagram)
- 6 – 1½″ x 7″ strips (#14 on the block diagram)

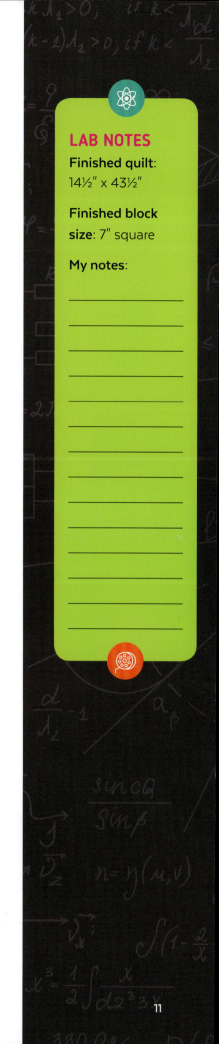

For the A blocks, from your light/low volume fabrics, cut:

- 6 – 1½" x 1½" squares (#1 on the block diagram)
- 6 – 1" x 2½" strips (#3 on the block diagram)
- 6 – 1" x 3" strips (#4 on the block diagram)
- 6 – 1" x 4" strips (#7 on the block diagram)
- 6 – 1" x 4½" strips (#8 on the block diagram)
- 6 – 1" x 5½" strips (#11 on the block diagram)
- 6 – 1" x 6" strips (#12 on the block diagram)
- 6 – 1" x 7" strips (#15 on the block diagram)
- 6 – 1" x 7½" strips (#16 on the block diagram)

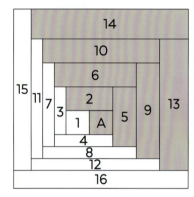

A Block

1. Starting with an A square and #1 square from above, place right sides together and sew with a ¼" seam allowance. Press seam towards the #1 square.

2. Continue adding pieces in number order around the block, pressing the seam towards the newly added strip each time.

3. When block is complete, trim to 7½" x 7½" if necessary. Repeat to make 6 A Blocks total.

CUTTING & MAKING THE B BLOCKS

Now we're going to repeat the process in reverse to make the alternate B Blocks. Once again, measurements include ¼" seam allowances.

For the B blocks, from your light/low volume fabrics, cut:

- 6 – 1½" x 1½" squares (B on the block diagram)
- 6 – 1½" x 2½" strips (#2 on the block diagram)
- 6 – 1½" x 3" strips (#5 on the block diagram)
- 6 – 1½" x 4" strips (#6 on the block diagram)
- 6 – 1½" x 4½" strips (#9 on the block diagram)
- 6 – 1½" x 5½" strips (#10 on the block diagram)
- 6 – 1½" x 6" strips (#13 on the block diagram)
- 6 – 1½" x 7" strips (#14 on the block diagram)

For the B blocks, from your dark fabrics, cut:

- 6 – 1½" x 1½" squares (#1 on the block diagram)
- 6 – 1" x 2½" strips (#3 on the block diagram)
- 6 – 1" x 3" strips (#4 on the block diagram)
- 6 – 1" x 4" strips (#7 on the block diagram)
- 6 – 1" x 4½" strips (#8 on the block diagram)
- 6 – 1" x 5½" strips (#11 on the block diagram)
- 6 – 1" x 6" strips (#12 on the block diagram)
- 6 – 1" x 7" strips (#15 on the block diagram)
- 6 – 1" x 7½" strips (#16 on the block diagram)

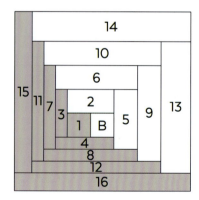

B Block

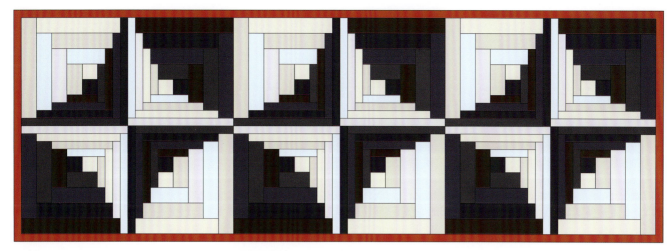

Table Runner Assembly Diagram option #1

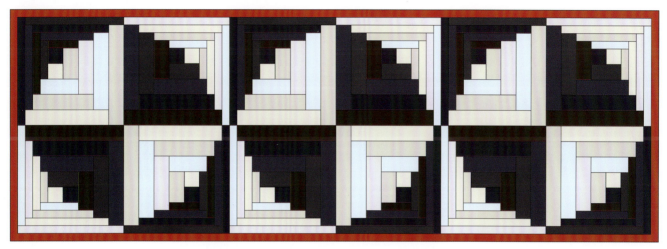

Table Runner Assembly Diagram option #2

4. This time, starting with a B square and #1 square from above, place right sides together and sew with a ¼" seam allowance. Press seam towards the #1 square.

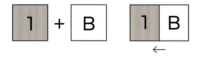

5. Continue adding pieces in number order around the block, pressing the seam towards the newly added strip each time.

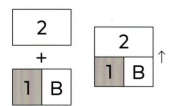

6. When block is complete, trim to 7½" x 7½" if necessary. Repeat to make 6 B Blocks total.

ASSEMBLE THE TABLE RUNNER

Now comes the hard part – deciding on a layout for your table runner! Referring to the Table Runner Assembly Diagram option #1 or #2 for block orientation, lay out the blocks in two rows. Sew together blocks in rows. Press the seams in rows in one direction, alternating direction with each row. Join the rows to complete the table runner. Press seams in one direction.

FINISH THE QUILT

Layer quilt top, batting, and backing. Baste, quilt and bind as desired.

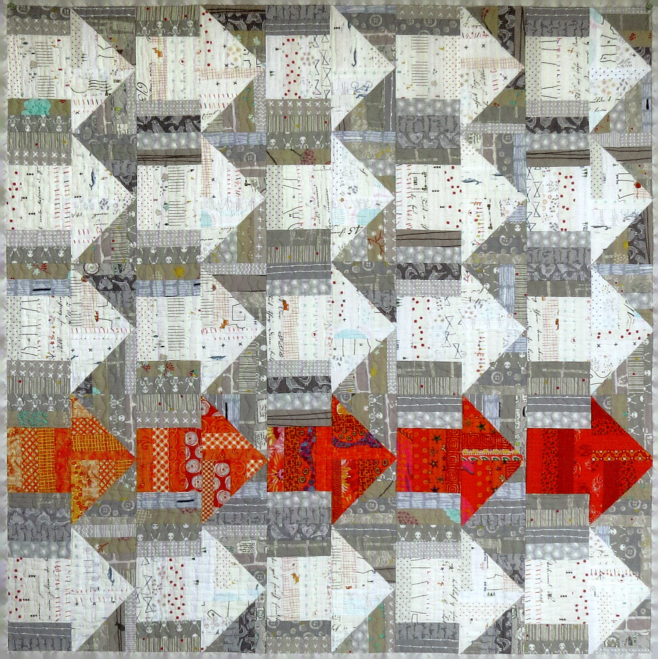

Exit Stage Left

Which does your eye see first? The gray arrows or the white? Color-blocking in the most subtle way — Exit Stage Left uses low volume white and gray/taupe to create a multi-directional setting for the bright, gradient shades of the orange arrows to follow. Substitute out the orange for another favorite color to make it unique and make it your own.

MATERIALS

Fabric amounts are estimated and include enough for blocks and binding:

- ¾ yard total assorted white/light/low volume prints
- ¾ yard total assorted gray/taupe prints
- ⅓ yard total assorted orange prints
- ¾ yard gray print for binding
- 2¾ yards backing fabric
- 49" square batting
- Acrylic ruler with 45° angle marking

CUTTING

Measurements include ¼" seam allowances.

From assorted white/light/low volume prints, cut:
- 55 – 1½" x 21 strips

From assorted gray/taupe prints, cut:
- 71 – 1½" x 21" strips

From assorted orange prints, cut:
- 25 – 1½" x 11" strips

From gray print for binding, cut:
- 5 – 2½" x width of fabric strips

PREPARE THE SEGMENTS

1. Aligning the long edges, sew together four assorted white print 1½" x 21" strips to make Strip Set A. Repeat to make five total of Strip Set A.

Cut A strip sets into 20 – 4½"-wide A segments. Each segment should be 4½" square.

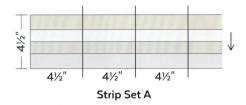

Strip Set A

2. In the same way, sew together five assorted white print 1½" x 21" strips to make Strip Set B. Repeat to make seven total of Strip Set B. Cut B strip sets into 20 – 5½"-wide B segments. Each segment should be 5½" square.

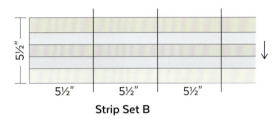

Strip Set B

3. Using assorted gray/taupe print 1½" x 21" strips, repeat Step 1 to make five of Strip Set C and cut them into 20 – 4½"-wide C segments.

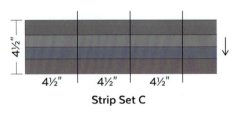

Strip Set C

4. Using assorted gray/taupe print 1½" x 21" strips, repeat Step 2 to make nine of Strip Set D and cut them into 25 – 5½"-wide D segments.

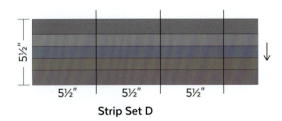

Strip Set D

5. Aligning long edges, sew together two assorted gray/taupe print 1½" x 21" strips to make Strip Set E. Repeat to make three total of Strip Set E. Cut E strip sets into 10 – 4½" -wide E segments. Each segment should be 2½" x 4½".

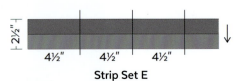

Strip Set E

6. Sort assorted orange print 1½" x 11" strips by value from lightest to darkest; then separate them into five groups of five strips each. The first group should have the lightest strips and the fifth group should have the darkest strips.

7. Aligning long edges, sew together FOUR STRIPS from each group sorted in Step 6 to make five of Strip Set F. Cut one 4½" -wide segment from each strip set.

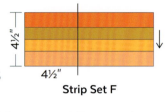

Strip Set F

8. Sew the remaining strip from each group sorted in Step 6 to the remainder of the corresponding strip set from Step 7 to make Strip Set G. Cut one 5½" -wide G segment from each strip set.

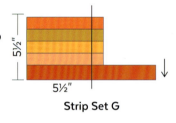

Strip Set G

MAKE THE TRIANGLE-SQUARE BLOCKS

1. Lay a white B segment on your work surface with the strips running horizontally. Use a pencil to mark a diagonal line on wrong side from upper left-hand to lower right-hand corner. Repeat to mark remaining white B segments and five gray D segments.

2. Layer a marked B segment on top of an unmarked gray D segment, right sides together; make sure the strips on each segment are horizontal. Sew together with two seams, stitching ¼" on each side of the drawn line.

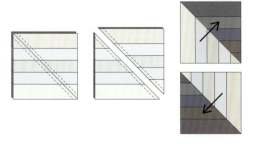

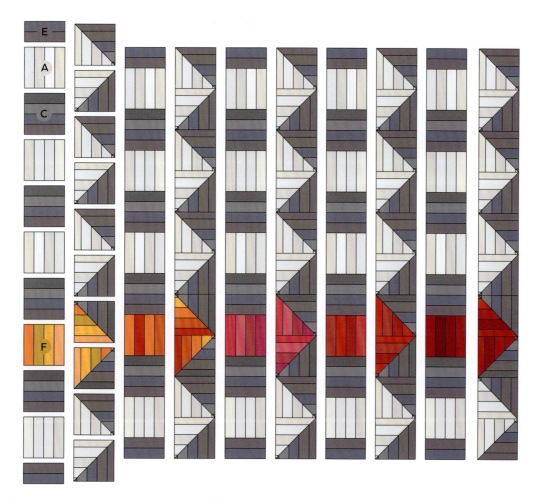

Quilt Assembly Diagram

3. Cut apart on the drawn line, and press open to make two gray and white triangle squares. Trim each triangle-square to 4½" square.

4. Repeat steps 2 and 3 to make 40 gray and white triangle-squares total.

5. Using marked gray D segments and the orange G segments, repeat steps 2 and 3 to make 10 gray and orange triangle-squares.

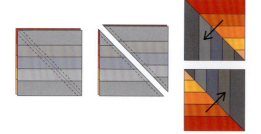

ASSEMBLE THE QUILT TOP

1. The quilt top is pieced in vertical rows. Referring to the Quilt Assembly Diagram for color placement and block orientation, lay out segments A, C, E, and F; gray and white triangle-squares; and gray and orange triangle-squares in 10 vertical rows. Rotate pieces as shown.

2. Sew together pieces in each row. In odd-numbered rows, press seams toward gray segments. In even-numbered rows, press seams open.

3. Join rows to complete the quilt top. Press seams in one direction.

4. Take a trip around the world! Sew a securing stitch line all the way around the edge of the quilt top between ⅛"-½" from the edge to secure all of the seams.

FINISH THE QUILT

Layer quilt top, batting, and backing. Baste, quilt, and bind.

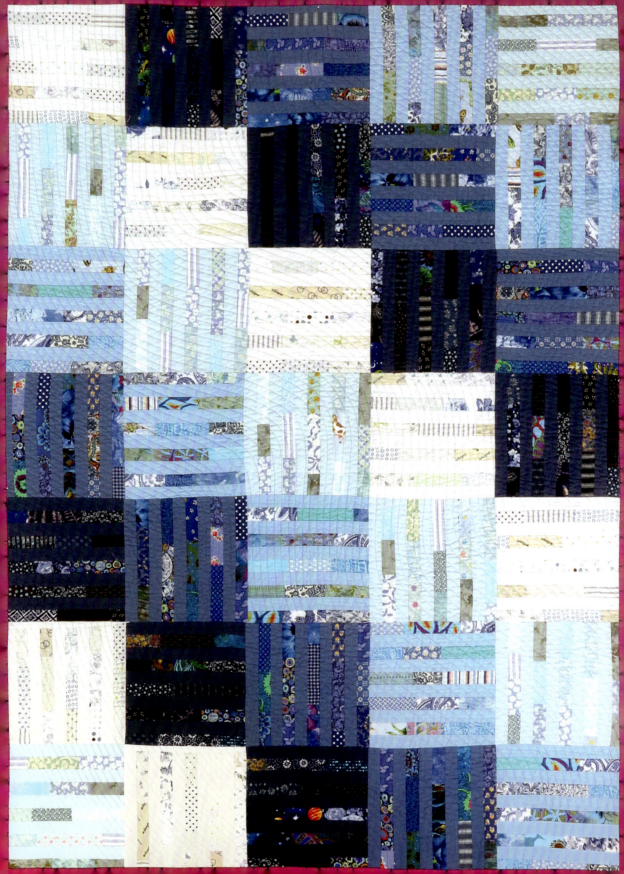

Ombre Loco

If your scrap bucket overflows with one particular color or you want to feature a favorite color, this may be just the right project for you. Ombre Loco pairs your abundance of scraps with an Ombre or gradient fabric of 5 shades, light to dark, to frame (and tame!) your scraps into a unique take on a traditional rail fence quilt layout.

MATERIALS

- ½ yard cream/white solid fabric
- 2 yards gradient Ombre blue fabric that can be divided into 4 shades of blue....or
 Substitute Ombre blue fabric with:
 — ½ yard light blue #1 solid fabric
 — ½ yard medium-light blue #2 solid fabric
 — ½ yard medium blue #3 solid fabric
 — ½ yard dark blue #4 solid fabric
- Assorted blue print scrap fabrics of varying shades of blue
- ⅝ yard magenta print fabric for binding
- 4 yards backing fabric
- 60" x 80" batting

SORT YOUR FABRICS

All of the blocks are made from 1½" wide strips. Layout your 4 solid blue fabrics and your white solid fabric to create your shade categories. I like to think of the solids as the "frame" fabrics. They are going to create the frame for your scraps to live in to come together as an identifiable block in your overall design.

Start by sorting your scrap blue print strips by frame shade category. Don't worry about print design or other colors that may appear in your printed fabrics. Sort your scraps lightest to darkest, matching to the solid framing fabric as close as possible. Any mix of fabric styles will work together as long as the main color or feeling identifies with the color blue. Once the scraps are put together with the framing fabric, your eye will read the single color identity of each block. For the cream/white solid, pair with any blue print fabrics on a white or light background.

LAB NOTES
Finished quilt:
50½" x 70½"

Finished block size: 10" square

My notes:

Once your fabrics are sorted, store sorted blues with their corresponding blue solid framing fabric in separate gallon size plastic kitchen storage bags or other containers. Be sure to label each bag, it's easy to get them confused in the middle of the project.

CUTTING

If you are using a single Ombre fabric, you need to divide into 4 different shades, light to dark. Cut apart the Ombre fabric wherever the color changes to separate.

Focus on one color bag at a time. Measurements include ¼" seam allowances.

From your light solid blue #1 fabric, cut:
- 35 – 1½" x 12" strips

From the corresponding light blue scraps, cut:
- 1½" -wide strips of various lengths. These can be cut down into various brick sizes as you go. Bricks can be scraps anywhere from 1½" x 2½" – 6½" long. I find it easiest to cut lengths of bricks as needed while piecing the rows.

Repeat the cutting process for all four shades of blue and the cream/white fabrics.

MAKE THE BLOCKS

1. From your Blue # 1 bag, take the assorted blue scrap prints and lay out 3-5 bricks to make a row. Join the bricks together to create a row that measures 1½" x 12". Repeat to make 5 scrap brick rows.

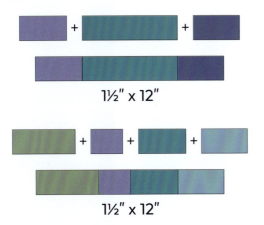

1½" x 12"

1½" x 12"

2. Take 5 - 1½" x 12" light solid blue #1 strips and lay them out alternating with the 5 scrap strip rows.

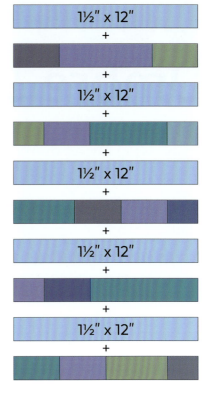

3. Place strips right sides together and sew along the long sides to make each block. Press the seams towards the solid blue fabric rows.

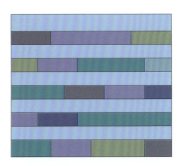

4. Trim the block to measure 10½" x 10½".

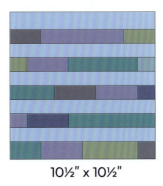

10½" x 10½"

5. Repeat steps 1-4 to make 7 blocks from Blue #1.

6. Repeat steps 1-5 for all four shades of blue and white. You will need 7 – 10½" x 10½" blocks from each sorted bag, 35 blocks total.

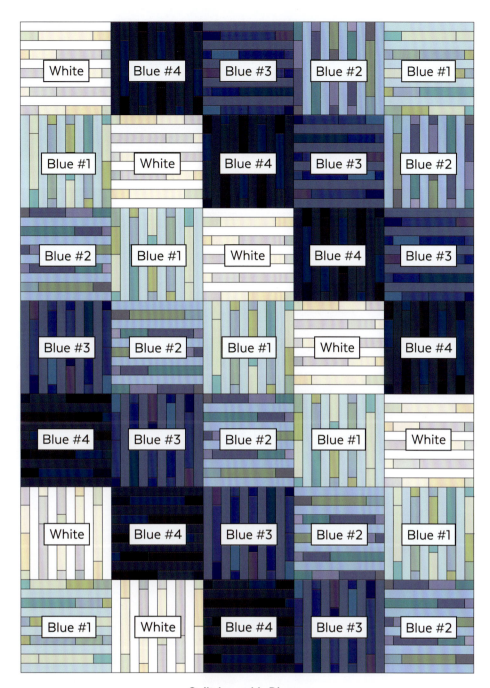

Quilt Assembly Diagram

ASSEMBLE THE QUILT TOP

1. Referring to the Quilt Assembly Diagram for color placement and block orientation, lay out the blocks in seven rows. Notice that the direction of the blocks alternates horizontally and vertically throughout.

2. Sew together blocks in rows. Press the seams in rows in one direction, alternating direction with each row.

3. Join the rows to complete the quilt top. Press seams in one direction.

4. Take a trip around the world! Sew a securing stitch line all the way around the edge of the quilt top between ⅛"–½" from the edge to secure all of the seams.

FINISH THE QUILT

Layer quilt top, batting, and backing. Baste, quilt and bind as desired.

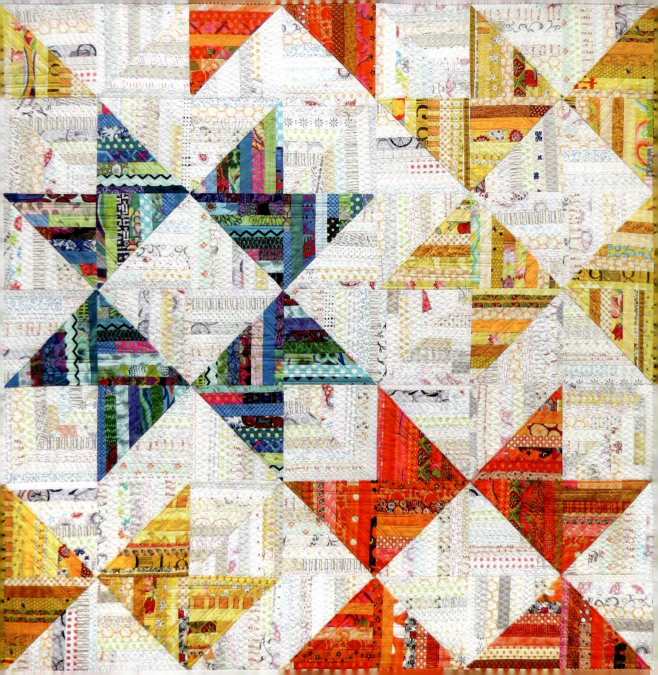

Rock Star

Time to rock your scraps! Sort your strings by color: lights/low volume fabrics, yellows, oranges, and blues. Any mix of fabric styles will work together as long as the main color identifies with the color group. This is color-blocking at its best. Your eye will read the color as a cohesive star, even with others mixed in – which makes the quilt more interesting to look at.

MATERIALS

Fabric amounts are estimated and include enough for blocks and binding:

- 3½" yards total assorted light/low volume prints
- 1 ⅜ yards total assorted yellow prints
- 1 ¼ yards total assorted orange prints
- 1 yard total assorted blue prints
- 3 ⅝ yards backing fabric
- 65" square batting
- Acrylic ruler with 45° angle marking

CUTTING

Measurements include ¼" seam allowances.

From assorted light/low volume prints, cut:
- Enough 2½" -wide strips to total 130" in length for binding
- 270 – 1½" x 10 strips

From assorted yellow prints, cut:
- Enough 2½" – wide strips to total 65" in length for binding
- 72 – 1½" x 10" strips

From assorted orange prints, cut:
- Enough 2½" – wide strips to total 60" in length for binding
- 54 – 1½" x 10" strips

From assorted blue prints, cut:
- 54 – 1½" x 10" strips

LAB NOTES

Finished quilt: 56½" x 56½"

Finished block size: 8" square

My notes:

MAKE THE BLOCKS

1. From your 1½" x 10" assorted light strips, start by laying out and sewing together 9 strips. Place strips right sides together and sew along the long sides to make each strip unit. Press seams all in the same direction. Trim edges of strip unit to 9½" x 9½". Repeat to make 30 light strip units total.

2. Using assorted yellow, orange and blue print strips, repeat step 1 to make 8 yellow strip units, 6 orange strip units, and 6 blue strip units.

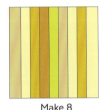 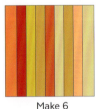 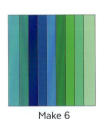

Make 8 Make 6 Make 6

3. Place a light 9½" strip unit on work surface with wrong side up and seams running vertically. Use a pencil to mark a diagonal line from top left-hand corner to bottom right-hand corner to make a Unit A. Repeat to make 19 A units total.

4. Place a light 9½" strip unit on work surface with wrong side up and seams running horizontally. Mark a diagonal line from top left-hand corner to bottom right-hand corner to make Unit B. Repeat to make 6 B units.

5. Layer an A unit and a yellow 9½" strip unit right sides together with seams of both units running in the same direction. Sew together with two seams, stitching ¼" on each side of the drawn line. Cut apart on the drawn line.

Press open to make two half square triangle squares. Press seam toward the yellow or darker fabric.

6. Aligning 45°angle of an acrylic ruler with the diagonal seam, center and trim each block to 8½" x 8½" to make two yellow blocks. Repeat to make 16 yellow blocks total.

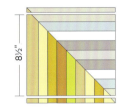 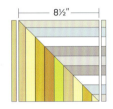

7. Using orange strip units instead of yellow strip units, repeat Step 5 to make 12 orange blocks.

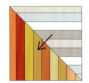

8. Using unmarked light strip units instead of the yellow/orange/blue units, repeat Step 5 to make 9 light blocks.

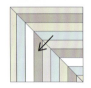

9. Layer a B unit on top of a blue unit with seams both running in the same direction. Stitch, cut apart, and trim as before to make two blue blocks. Repeat to make 12 blue blocks total.

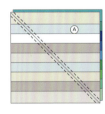 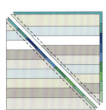 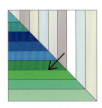

ASSEMBLE THE QUILT TOP

1. Referring to the Quilt Assembly Diagram for color placement and block orientation, lay out the blocks in seven rows. You will have one light block left over.

2. Sew together blocks in rows. Press the seams in rows in one direction, alternating direction with each row.

3. Sew the rows together and press the seam allowances in one direction to complete the quilt top.

4. Take a trip around the world! Sew a securing stitch line all the way around the edge of the quilt top between ⅛"–½" from the edge to secure all of the seams.

FINISH THE QUILT

1. Layer quilt top, batting, and backing. Baste and quilt as desired.

2. Prepare your binding. Using diagonal seams, sew together assorted light/low volume print 2½"-wide strips to make a light binding strip. Repeat with assorted yellow and orange print strips to make a yellow binding strip and an orange binding strip.

3. To continue block colors to quilt edges, match binding color to block edge color as you stitch. To begin, sew light binding strip to a long light quilt top section. Stop sewing about 10" before you reach a yellow or orange block edge. Pin light binding strip in place up to the block seam; cut binding strip ¼" beyond that point. Unpin light binding strip and join it to next-color binding strip with a straight (not bias) seam. Pin pieced binding strip to quilt top and continue stitching, stopping 10" before next color change. Continue in same manner, trimming and joining binding colors, until you reach the starting point.

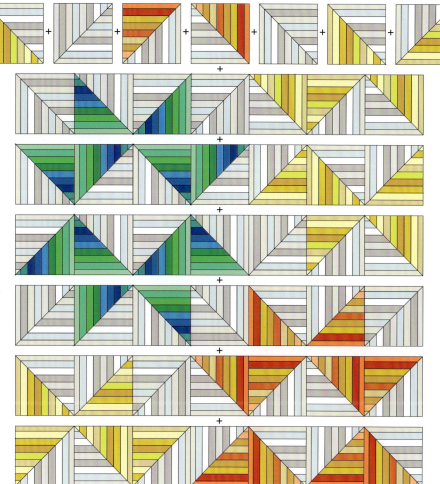

Quilt Assembly Diagram

ALTERNATE PROJECT OPTION

"Big String Star" – using the same block construction as used in Rock Star, you can make this smaller wall-hanging version with as few as 16 HST string blocks – four of these make the corners and are made from two light/low volume blocks instead of light/dark HSTs. "Big String Star" as shown at right measures 38" x 38".

Simple Gifts

Simple Gifts offers another variation of the traditional log cabin quilt block, this time using a muslin foundation method for construction. Simple Gifts needs only a small amount of scraps and is a quick and satisfying project to dress up your tabletop for any celebration. The blue, pink, green and purple colors shown are perfect for a birthday month or change up to match up your favorite holiday décor.

MATERIALS

- Assorted light/low volume print scrap fabrics
- Assorted blue, green, pink, and purple print scrap fabrics
- ¼ yard bright print fabric for binding
- 1 yard muslin for foundation squares
- 4½ yards fabric ribbon
- Liquid seam sealant (like Dritz Fray Check)
- 1 yard backing fabric
- 28" x 28" batting

CUTTING

Measurements include ¼" seam allowances.

From the muslin, cut:
- 4 – 12½" x 12½" squares

From your blue fabrics, cut:
- 1 – 1½" x 2½" strip (#3 on the block diagram)
- 3 – 1½" x 3½" strips (#1, 2 & 5 on the block diagram)
- 2 – 1½" x 4½" strips (#4 & 7 on the block diagram)
- 2 – 1½" x 5½" strips (#6 & 9 on the block diagram)
- 2 – 1½" x 6½" strips (#8 & 11 on the block diagram)
- 2 – 1½" x 7½" strips (#10 & 13 on the block diagram)
- 1 – 1½" x 8½" strip (#12 on the block diagram)
- 1 – 1½" x 9½" strip (#14 on the block diagram)
- Repeat these cuts for the pink, purple and green fabrics.

From your light/low volume fabrics, cut:

- 4 – 1½" x 8½" strips (#LV1 on the block diagram)
- 4 – 1½" x 9½" strips (#LV3 on the block diagram)
- 8 – 1½" x 10½" strips (#LV2 & LV5 on the block diagram)
- 4 – 1½" x 11½" strips (#LV4 on the block diagram)
- 8 – 1½" x 12½" strips (#LV6 & LV7 on the block diagram)

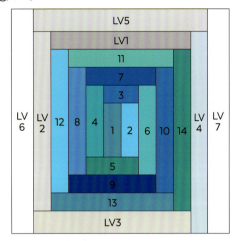

MAKE THE BLOCKS

1. Fold a 12½" x 12½" muslin square in half twice into quarters and finger press to make registration lines.

2. Place a blue #1 strip right side up on the muslin square just below and to the left of center as shown.

3. Place a blue #2 strip directly on top of strip #1 right sides together. Sew ¼ seam down the right side. Sew through all three layers of fabric.

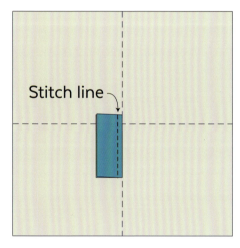

4. Flip open and press seam towards strip #2. Continue to add strips in order around the block, pressing the seams towards the newly added strip each time.

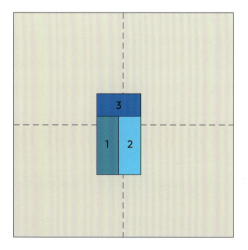